DesignOriginals

Creative Coloring
Inspirations

Valentina Harper

DESIGN ORIGINALS
an Imprint of Fox Chapel Publishing
www.d-originals.com

Basic Color Ideas

In order to truly enjoy this coloring book, you must remember that there is no wrong way—or right way—to paint or use color. My drawings are created precisely so that you can enjoy the process no matter what method you choose to use to color them!

The most important thing to keep in mind is that each illustration was made to be enjoyed as you are coloring, to give you a period of relaxation and fun at the same time. Each picture is filled with details and forms that you can choose to color in many different ways. I value each person's individual creative process, so I want you to play and have fun with all of your favorite color combinations.

As you color, you can look at each illustration as a whole, or you can color each part as a separate piece that, when brought together, makes the image complete. That is why it is up to you to choose your own process, take your time, and, above all, enjoy your own way of doing things.

To the right are a few examples of ways that you can color each drawing.

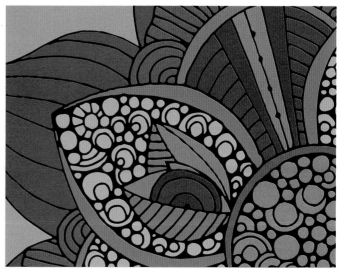

Color each section of the drawing (every general area, not every tiny shape) in one single color.

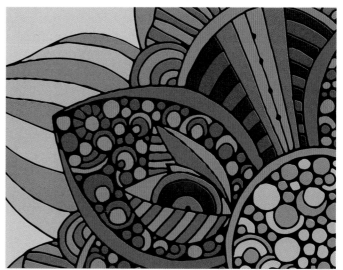

Within each section, color each detail (small shape) in alternating colors.

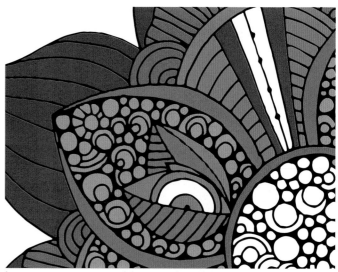

Leave some areas white to add a sense of space and lightness to the illustration.

Basic Color Tips

As an artist, I love to mix techniques, colors, and different mediums when it comes time to add color to my works of art. And when it comes to colors, the brighter the better! I feel that with color, illustrations take on a life of their own.

Remember: when it comes to painting and coloring, there are no rules. The most fun part is to play with color, relax, and enjoy the process and the beautiful finished result.

Feel free to mix and match colors and tones. Work your way from primary colors to secondary colors to tertiary colors, combining different tones to create all kinds of different effects. If you aren't familiar with color theory, below is a quick, easy guide to the basic colors and combinations you will be able to create.

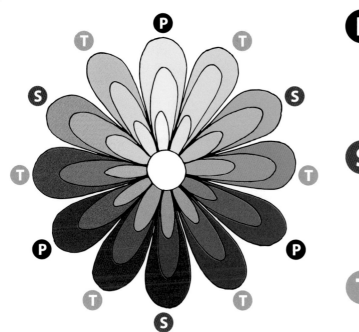

Primary colors: These are the colors that cannot be obtained by mixing any other colors; they are yellow, blue, and red.

Secondary colors: These colors are obtained by mixing two primary colors in equal parts; they are green, purple, and orange.

Tertiary colors: These colors are obtained by mixing one primary color and one secondary color.

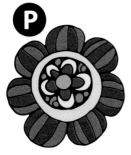

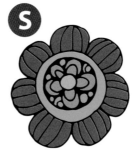

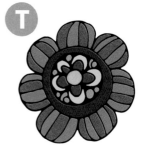

Don't be afraid of mixing colors and creating your own palettes. Play with colors—the possibilities are endless!

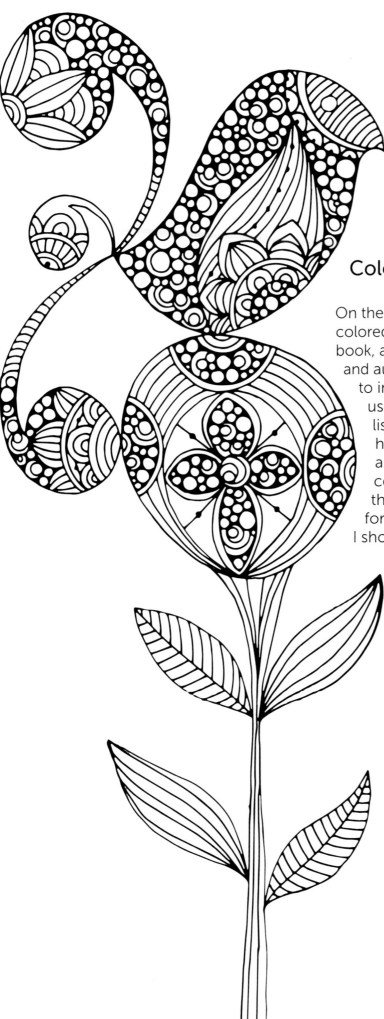

Color Inspiration

On the following eight pages, you'll see fully colored samples of my illustrations in this book, as interpreted by one talented artist and author, Marie Browning. I was delighted to invite Marie to color my work, and she used many different mediums to do so, all listed below each image. Take a look at how Marie decided to color the doodles, and find some inspiration for your own coloring! After the colored samples, the thirty delightful drawings just waiting for your color begin. Remember the tips I showed you earlier, think of the color inspiration you've seen, and choose your favorite medium to get started, whether it's pencil, marker, watercolor, or something else. Your time to color begins now, and only ends when you run out of pages! Have fun!

Valentina Harper

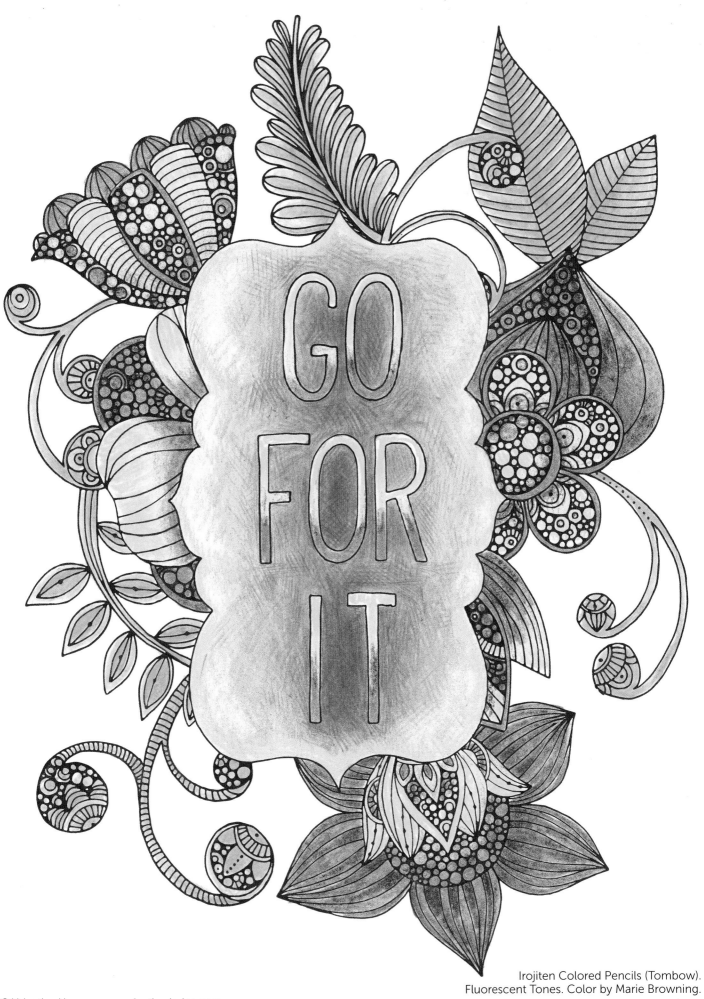

GO
FOR
IT

Irojiten Colored Pencils (Tombow).
Fluorescent Tones. Color by Marie Browning.

© Valentina Harper, www.valentinadesign.com

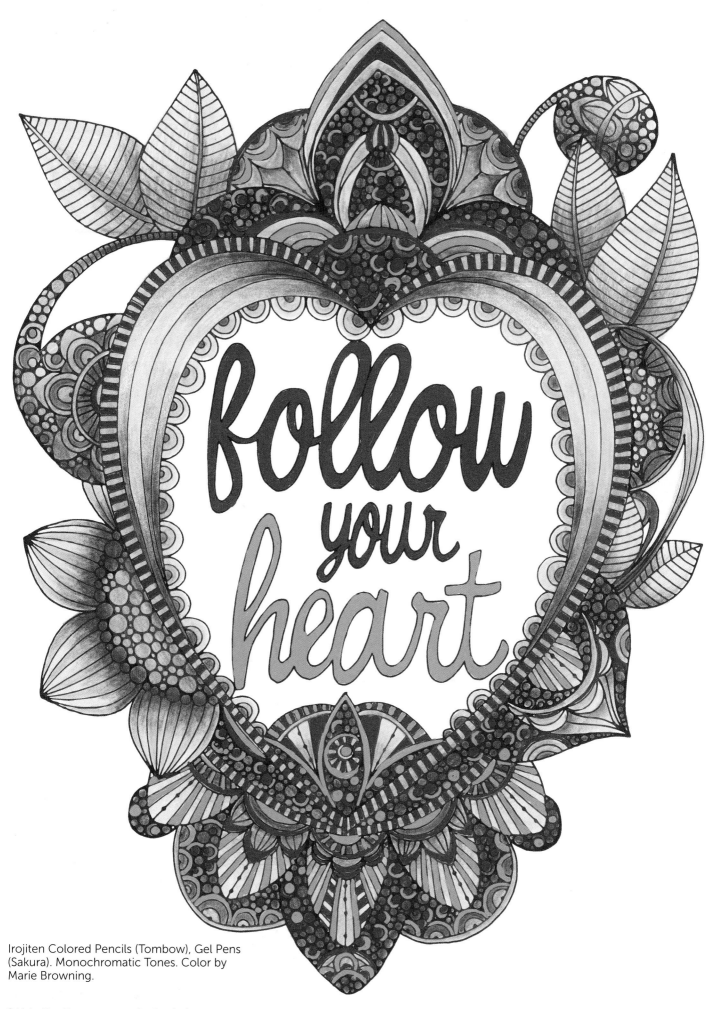

Irojiten Colored Pencils (Tombow), Gel Pens (Sakura). Monochromatic Tones. Color by Marie Browning.

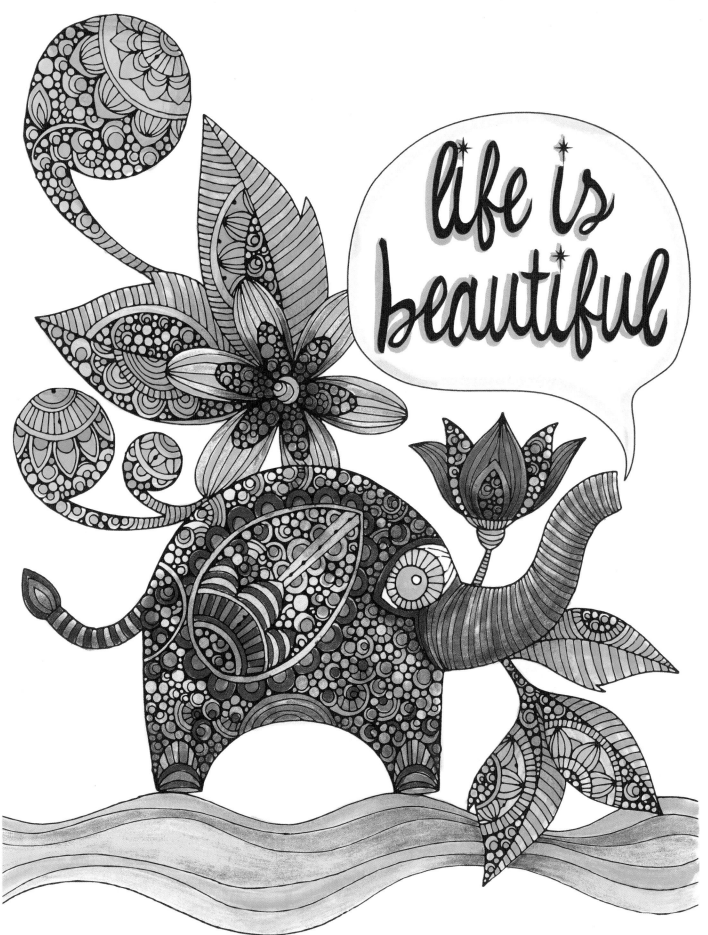

Dual Brush Markers (Tombow), Irojiten Colored Pencils
(Tombow). Vivid Tones. Color by Marie Browning.

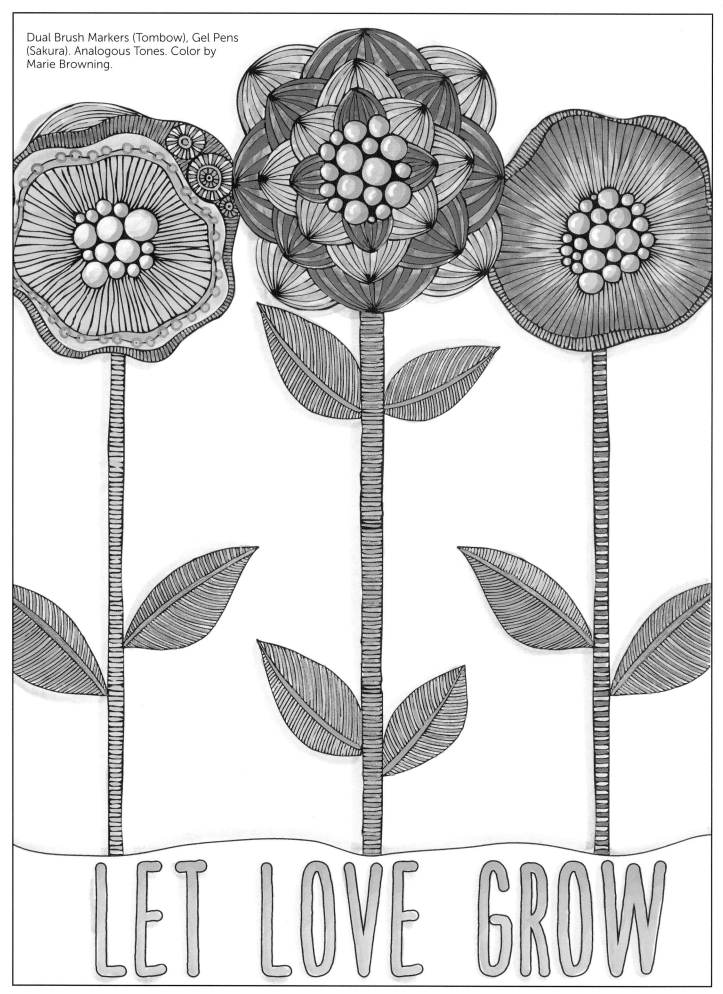

Dual Brush Markers (Tombow), Gel Pens (Sakura). Analogous Tones. Color by Marie Browning.

LET LOVE GROW

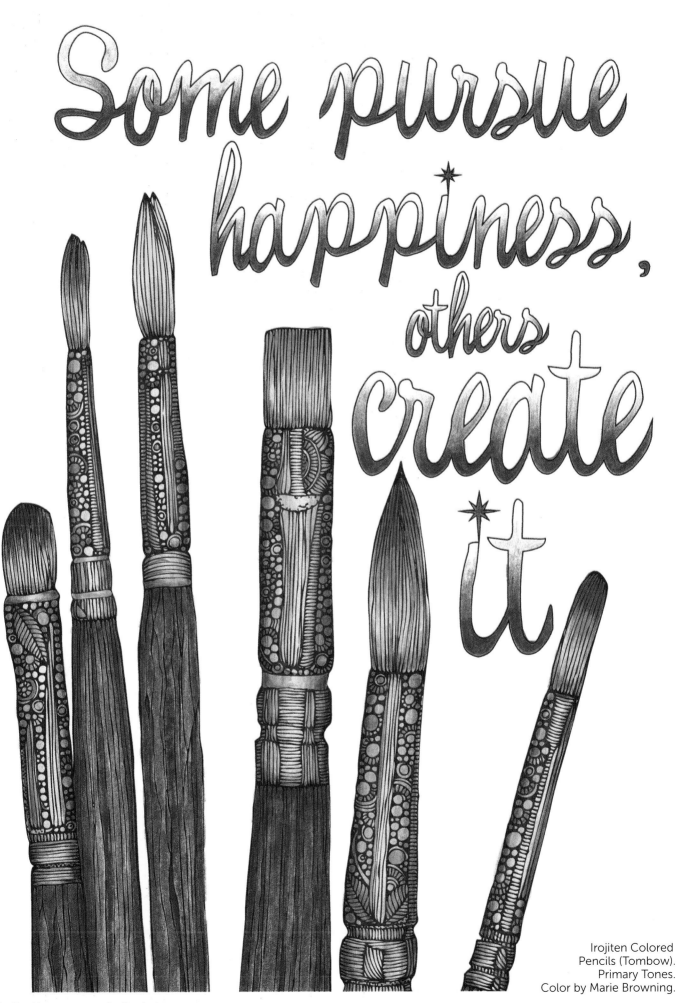

Some pursue happiness, others create it

Irojiten Colored Pencils (Tombow). Primary Tones. Color by Marie Browning.

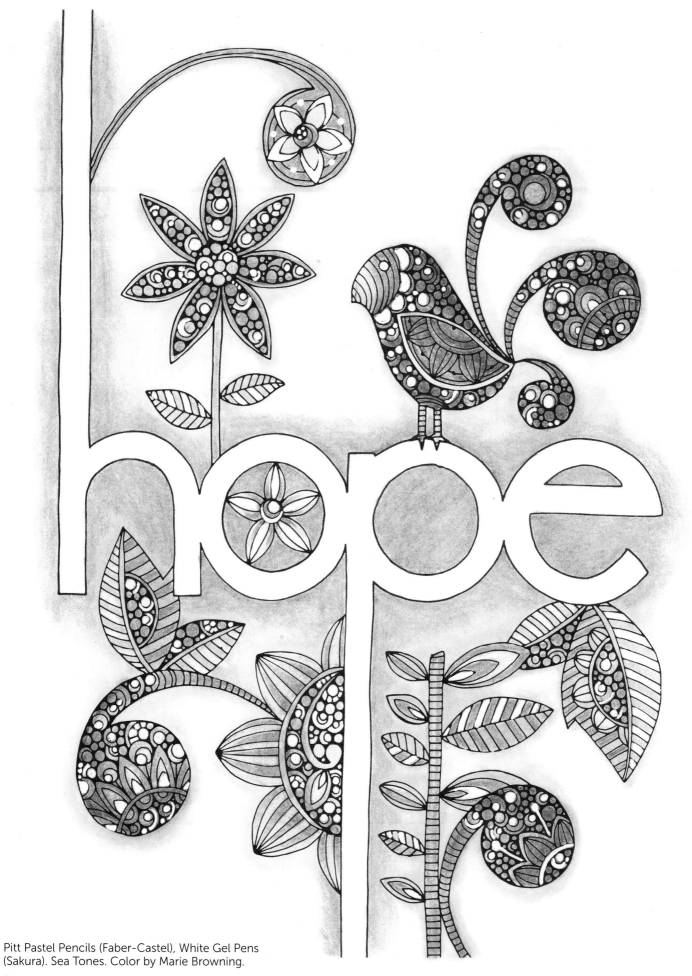

Pitt Pastel Pencils (Faber-Castel), White Gel Pens
(Sakura). Sea Tones. Color by Marie Browning.

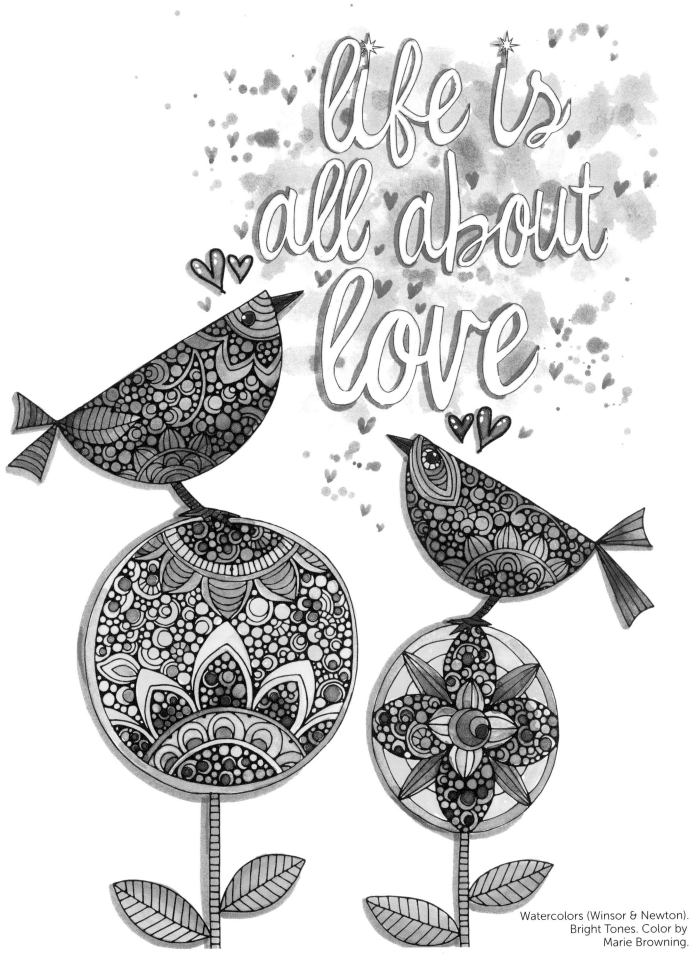

life is all about love

Watercolors (Winsor & Newton).
Bright Tones. Color by
Marie Browning.

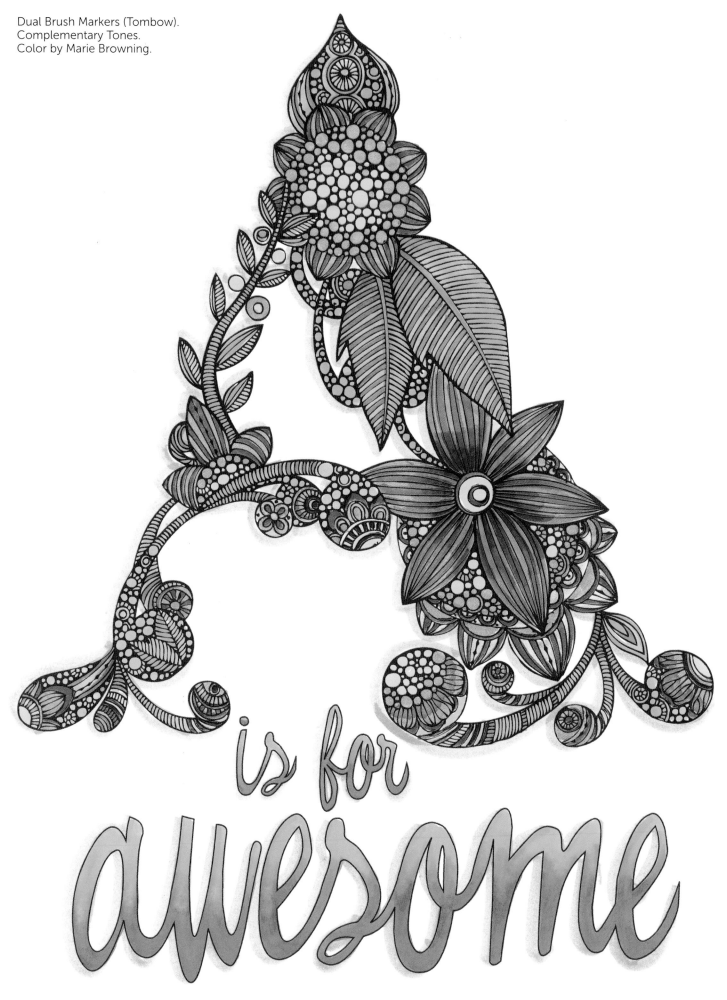

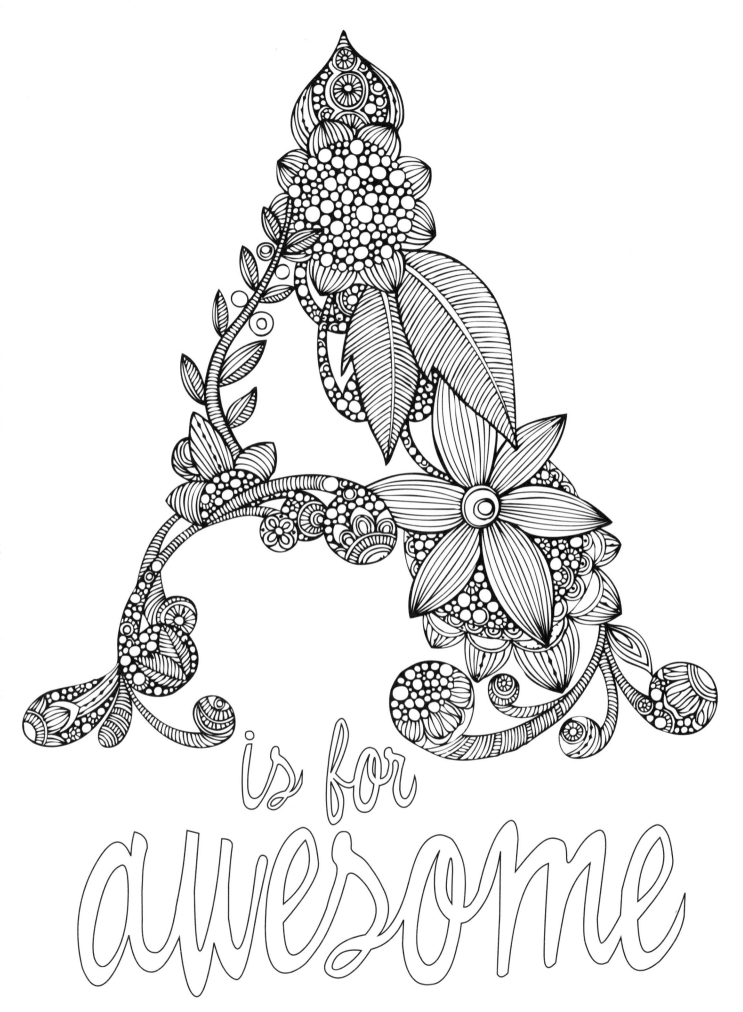

is for awesome

Do not stop thinking of life as an adventure.

—Eleanor Roosevelt

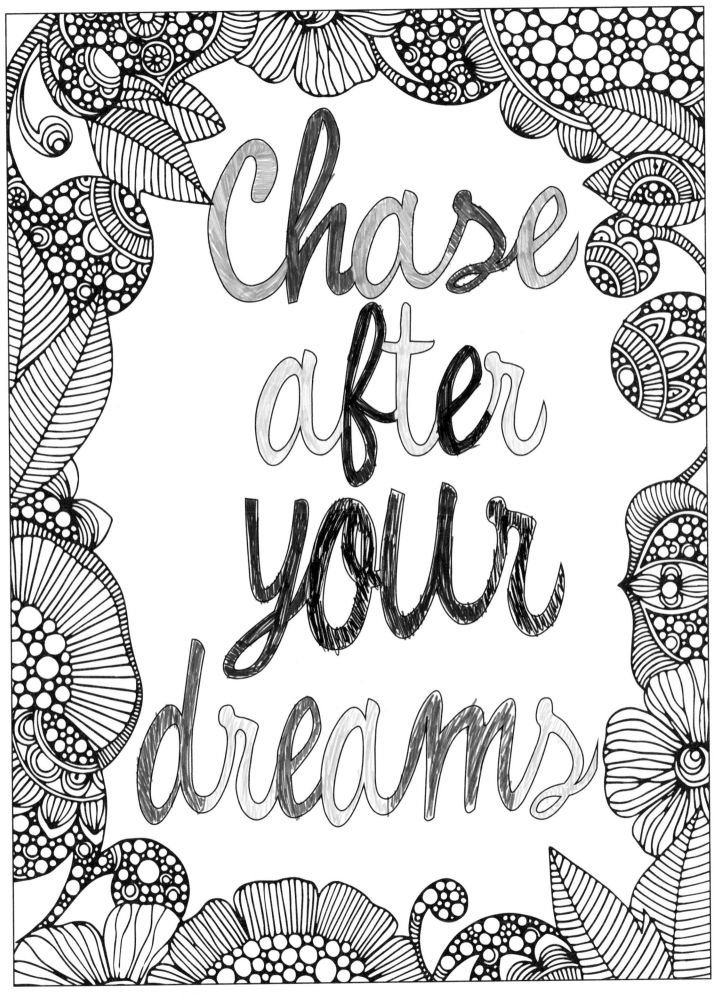

© Valentina Harper, www.valentinadesign.com

If you never chase your dreams,
you'll never catch them.

—Unknown

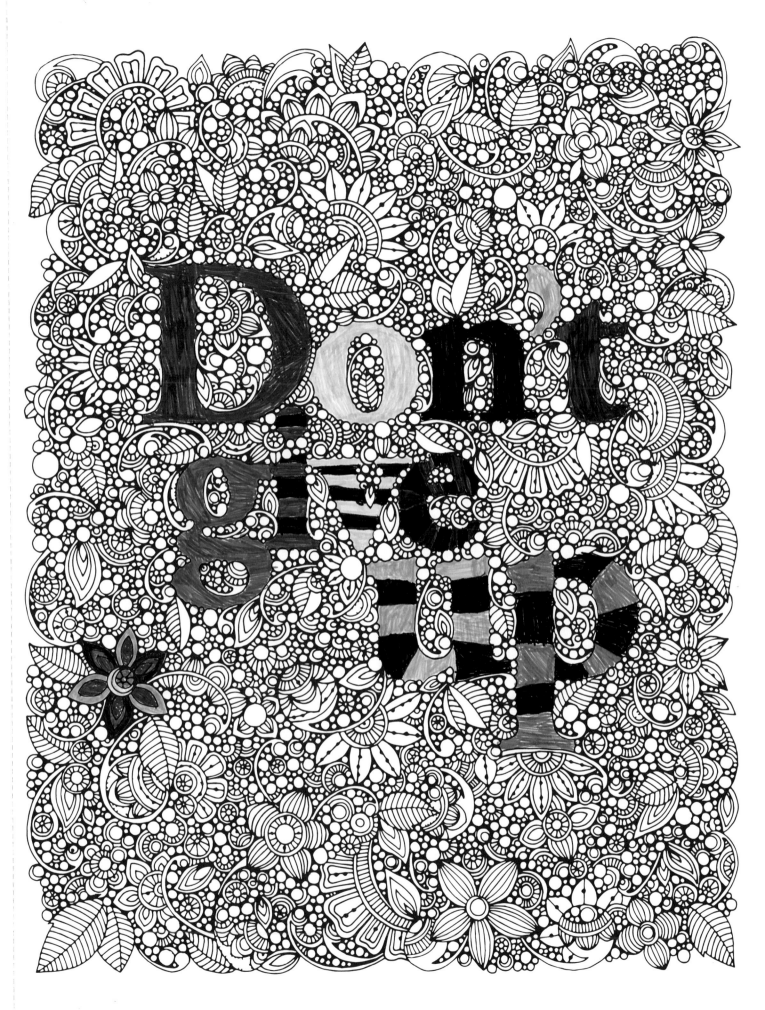

I have not failed.
I've just found 10,000 ways that won't work.

—Thomas Edison

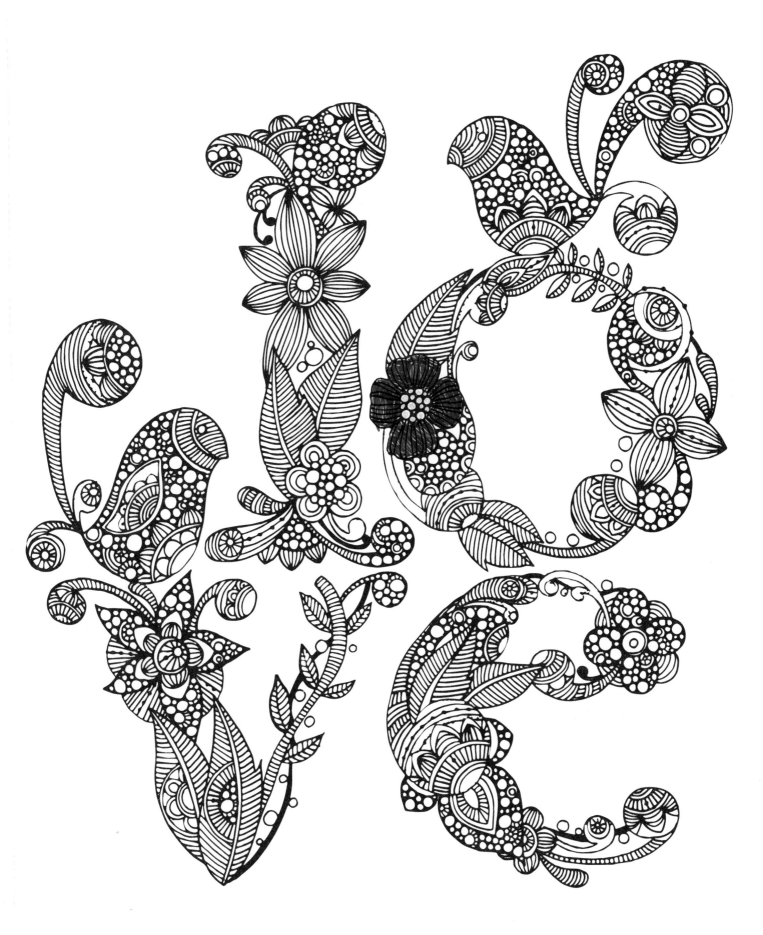

love (English)

amor (Spanish)

liefde (Afrikaans)

liebe (German)

αγάπη (Greek)

amour (French)

sayang (Indonesian)

ljubav (Serbian)

愛 (Japanese)

amore (Italian)

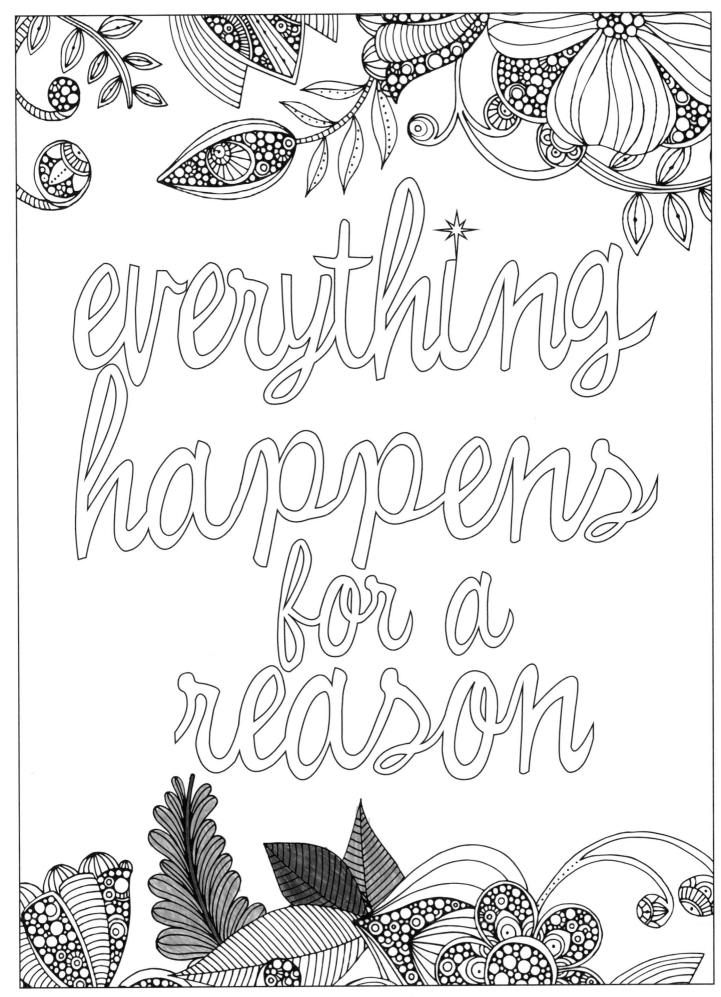

everything happens for a reason

I may not have gone where I intended to go,
but I think I have ended up where
I intended to be.

—Unknown

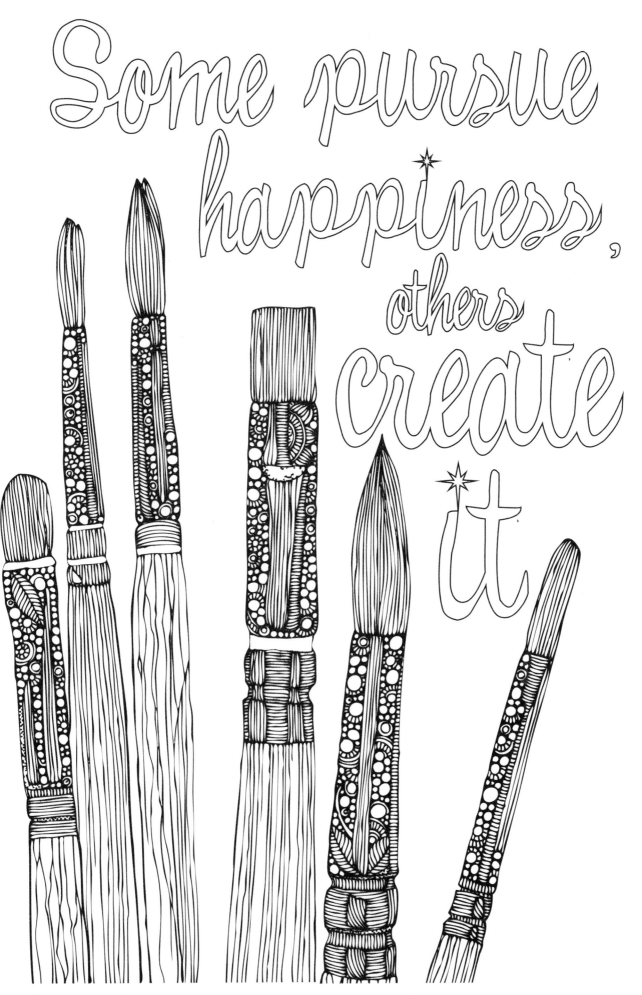

Three grand essentials to happiness in this life
are something to do, something to love,
and something to hope for.

—Joseph Addison

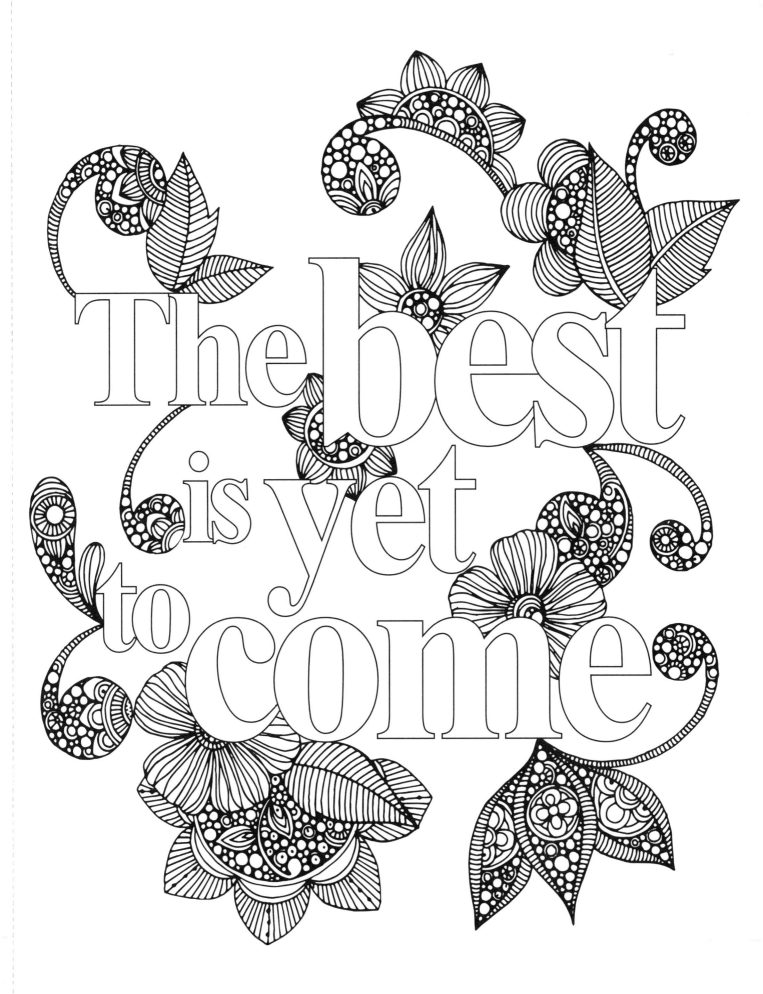

There are far, far better things ahead
than any we leave behind.

—C.S. Lewis

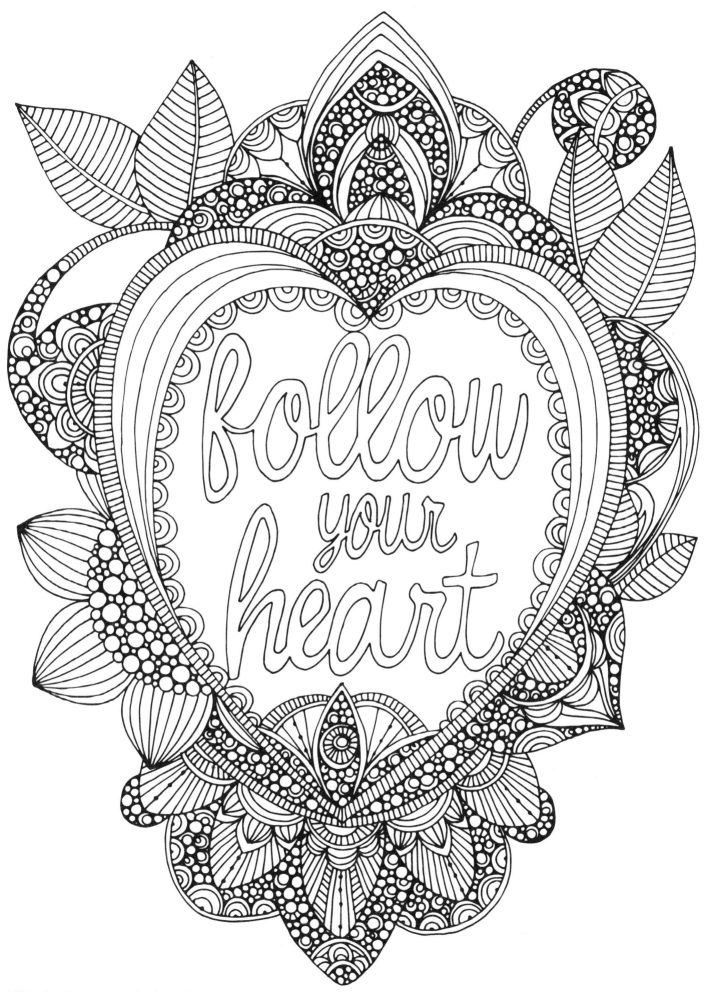

Don't let the noise of others' opinions
drown out your own inner voice.

—Steve Jobs

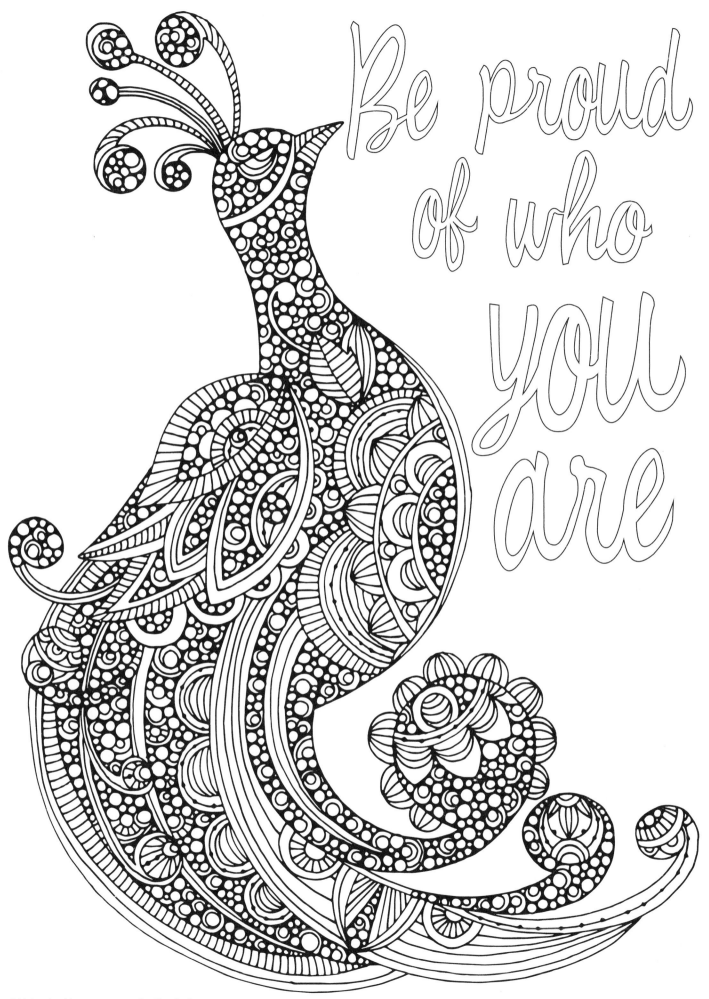

Be proud
of who
you
are

No one can make you feel inferior
without your consent.

—Eleanor Roosevelt

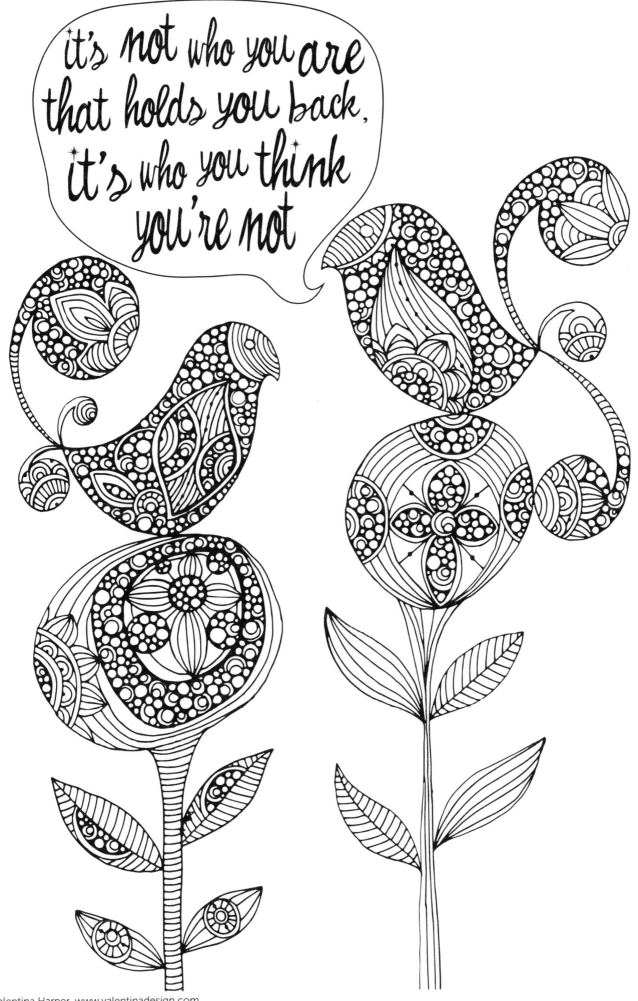

Whether you think you can or
think you can't—you are right.

—Henry Ford

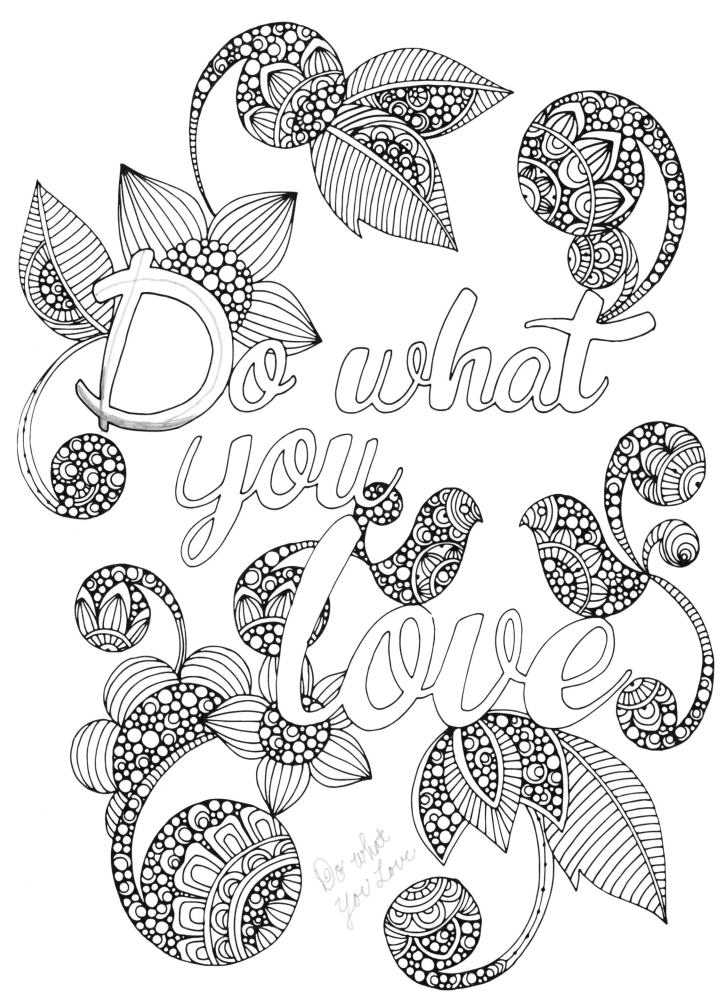

Do what you love

Follow your heart,
but take your brain with you.

—Unknown

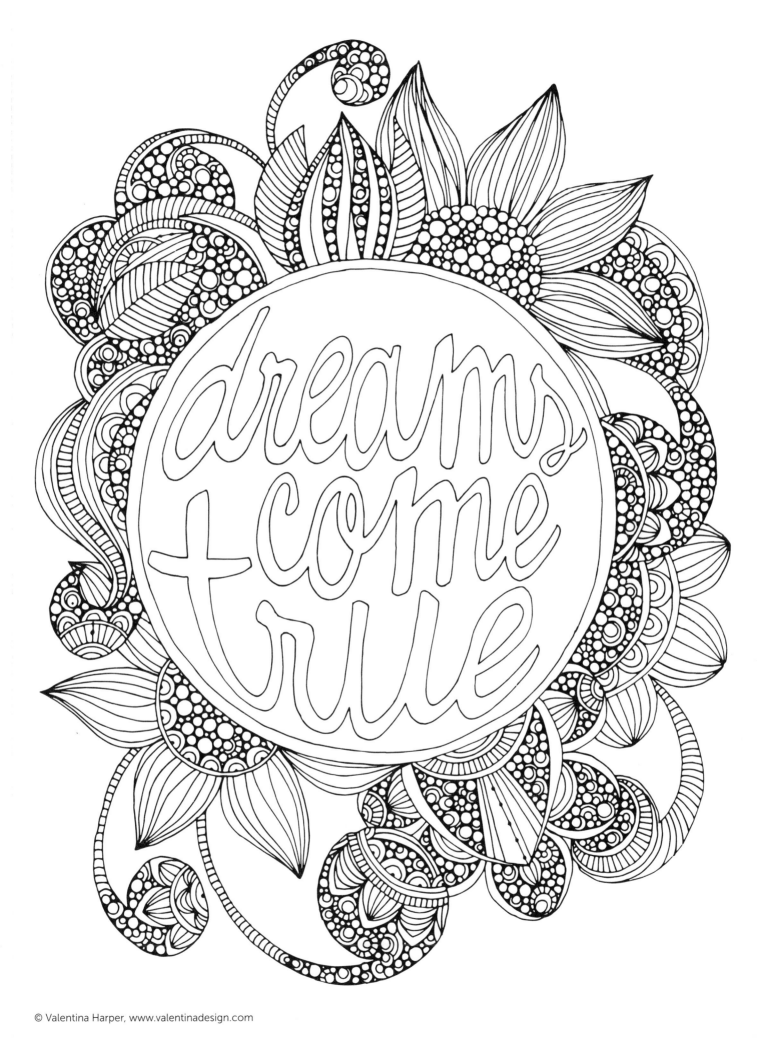

At first dreams seem impossible,
then improbable, then inevitable.

—Christopher Reeve

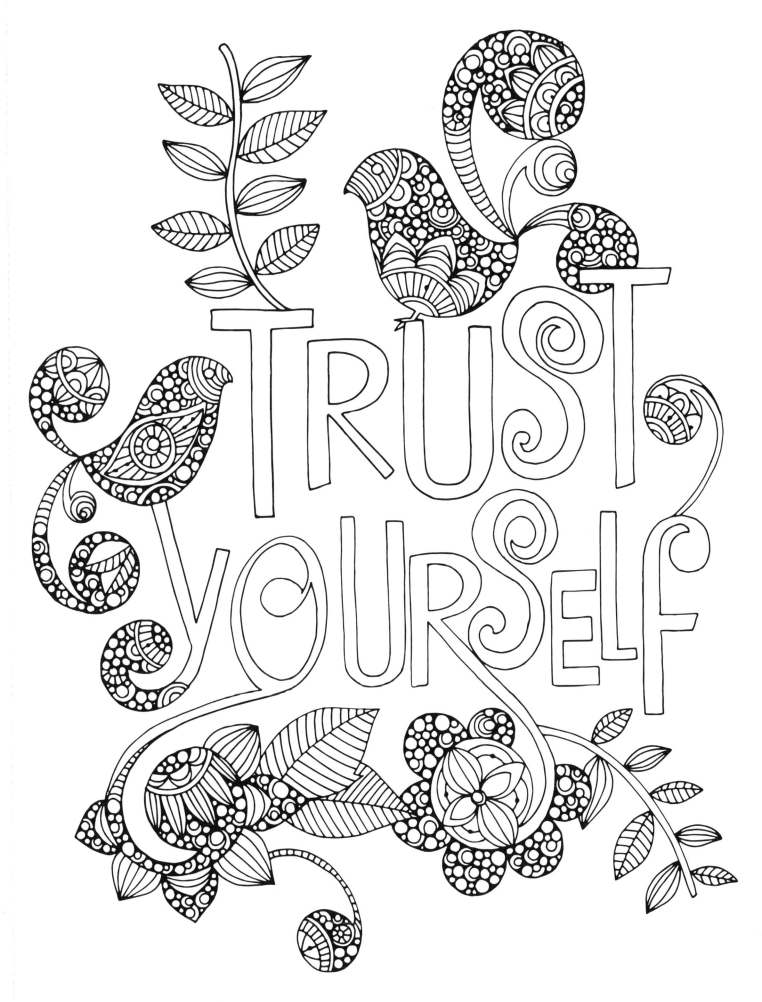

Make the most of yourself,
for that is all there is of you.

—Ralph Waldo Emerson

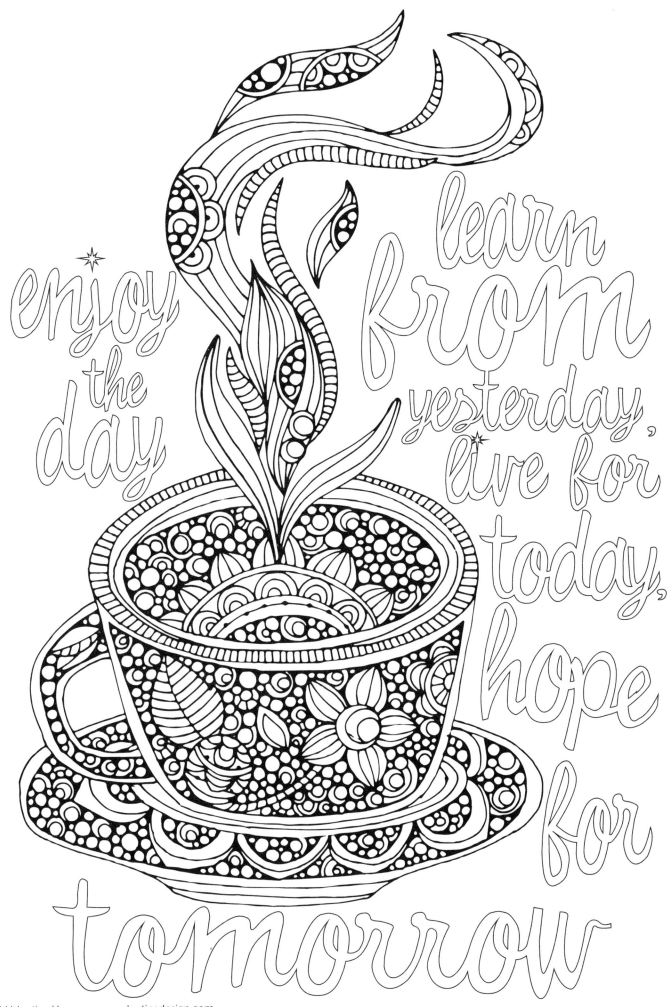

Remember that your natural state is joy.

—Wayne Dyer

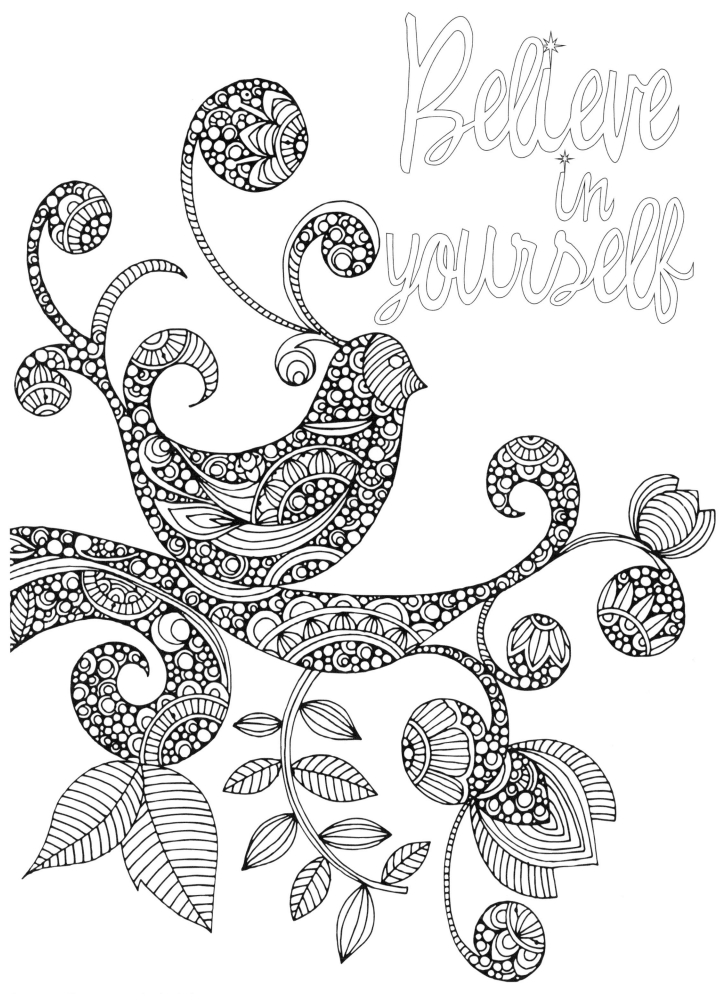

You can, you should,
and if you're brave enough to start, you will.

—Stephen King

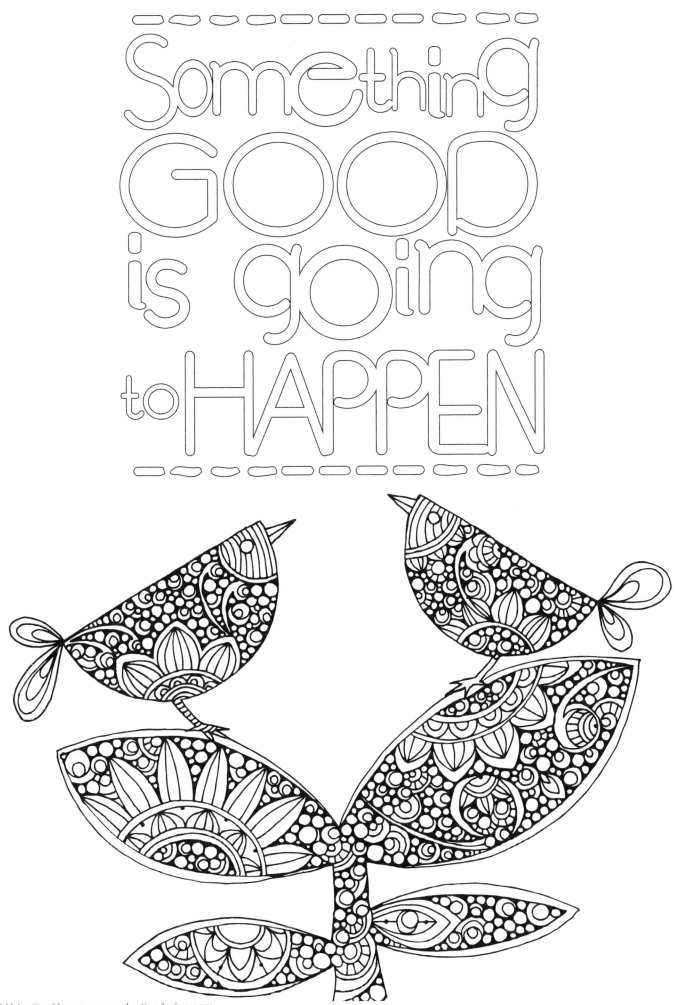

Something GOOD is going to HAPPEN

Nothing in life is to be feared.
It is only to be understood.

—Marie Curie

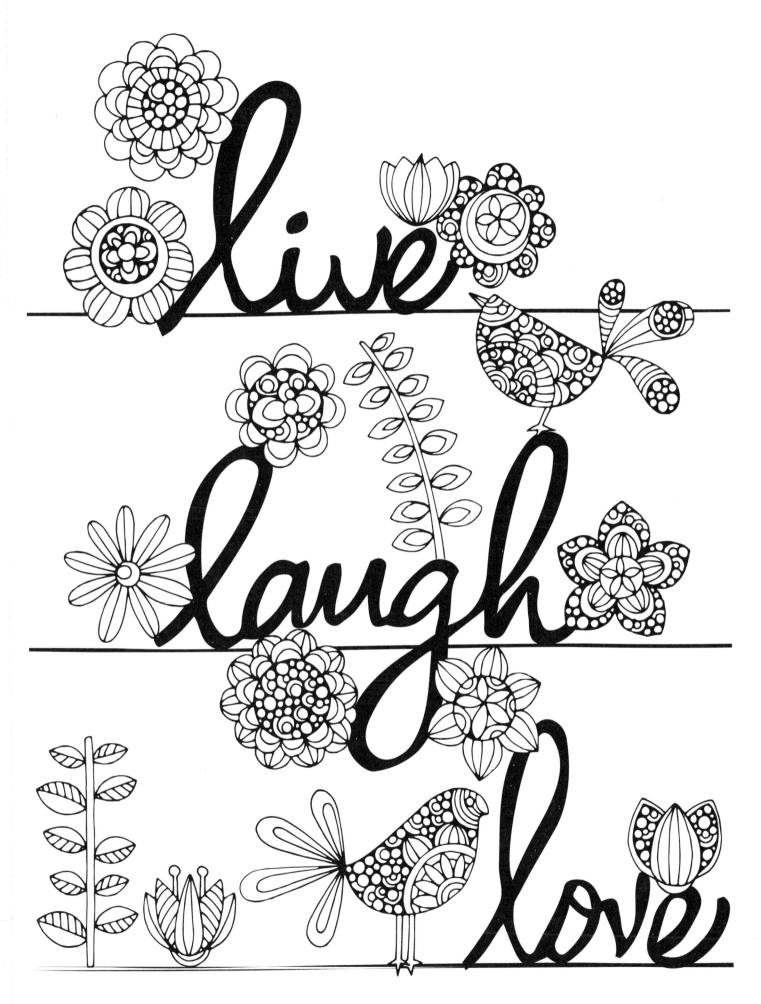

Love the life you live.
Live the life you love.

—Bob Marley

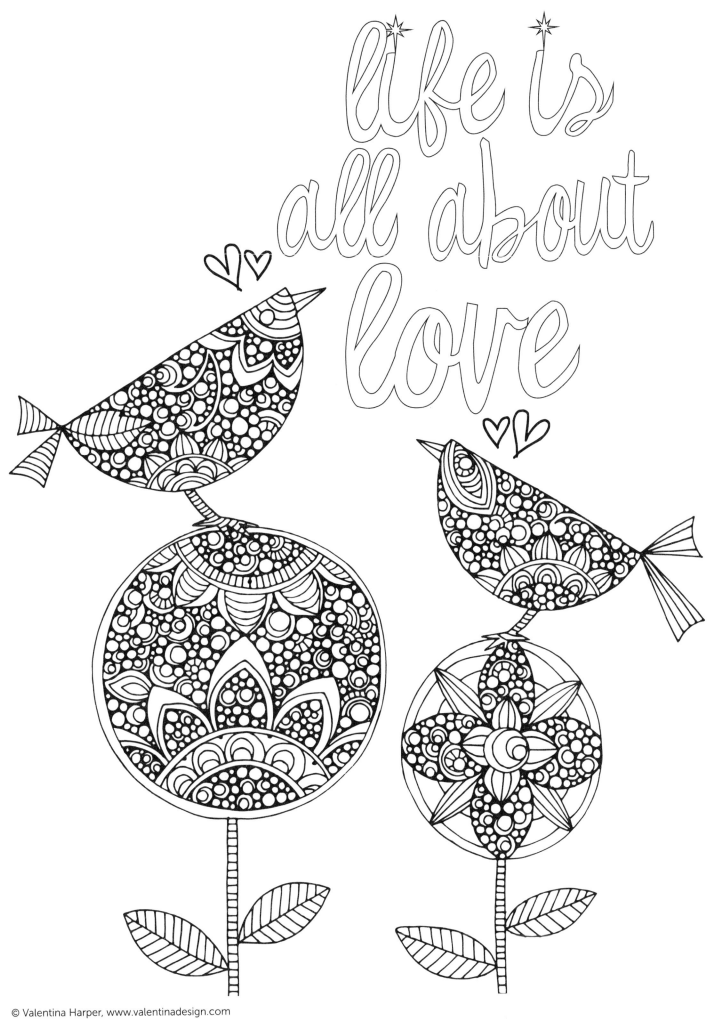

When you love and laugh abundantly
you live a beautiful life.

—Unknown

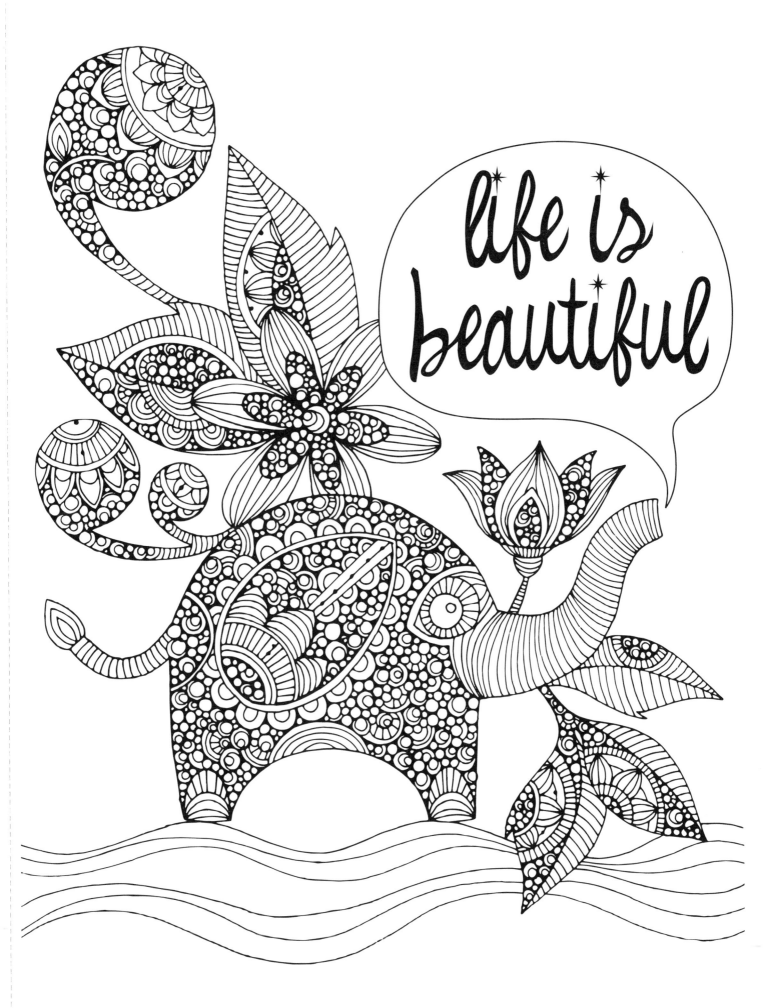

You can't do anything about the length of your life,
but you can do something about its width and depth.

—Evan Esar

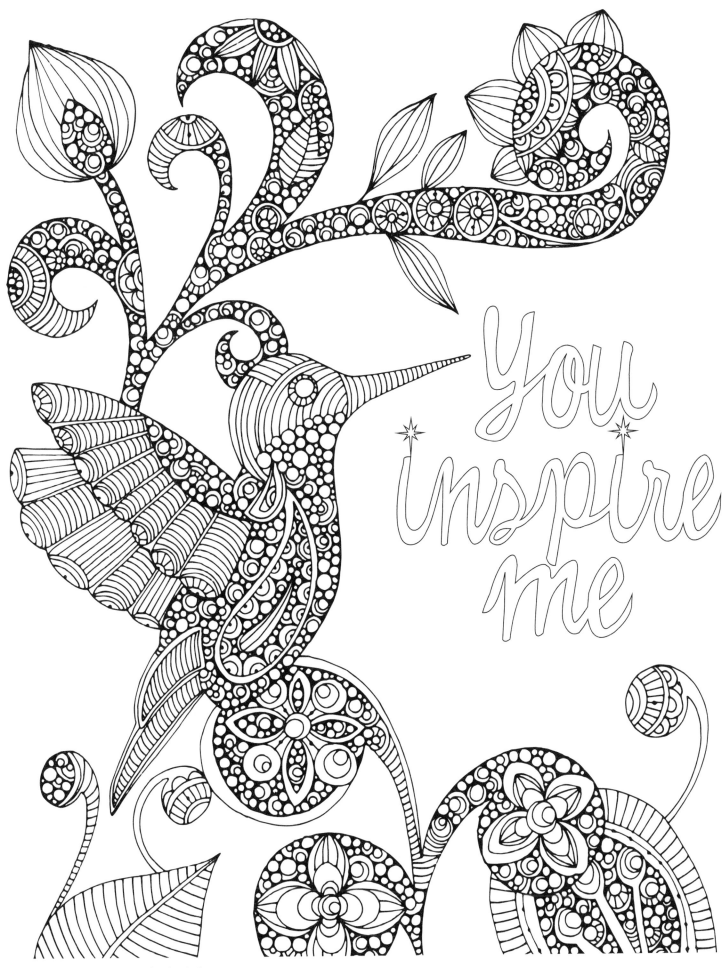

You inspire me

You don't need a certain number of friends,
just a number of friends you can be certain of.

—Unknown

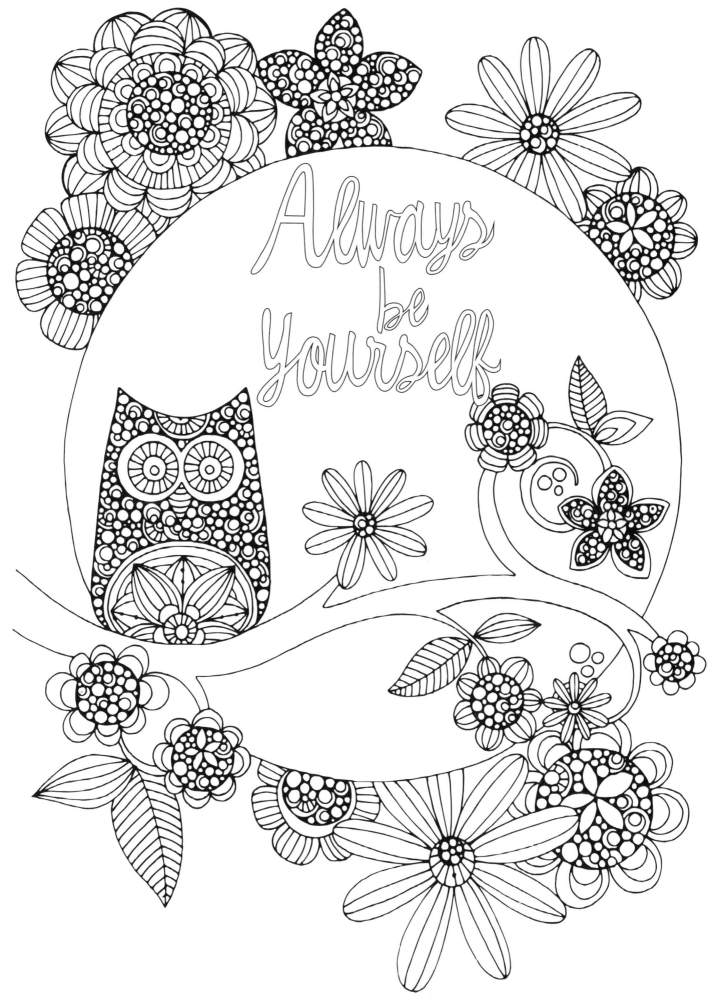

Be who you are and say what you feel
because those who mind don't matter and
those who matter don't mind.

—Dr. Seuss

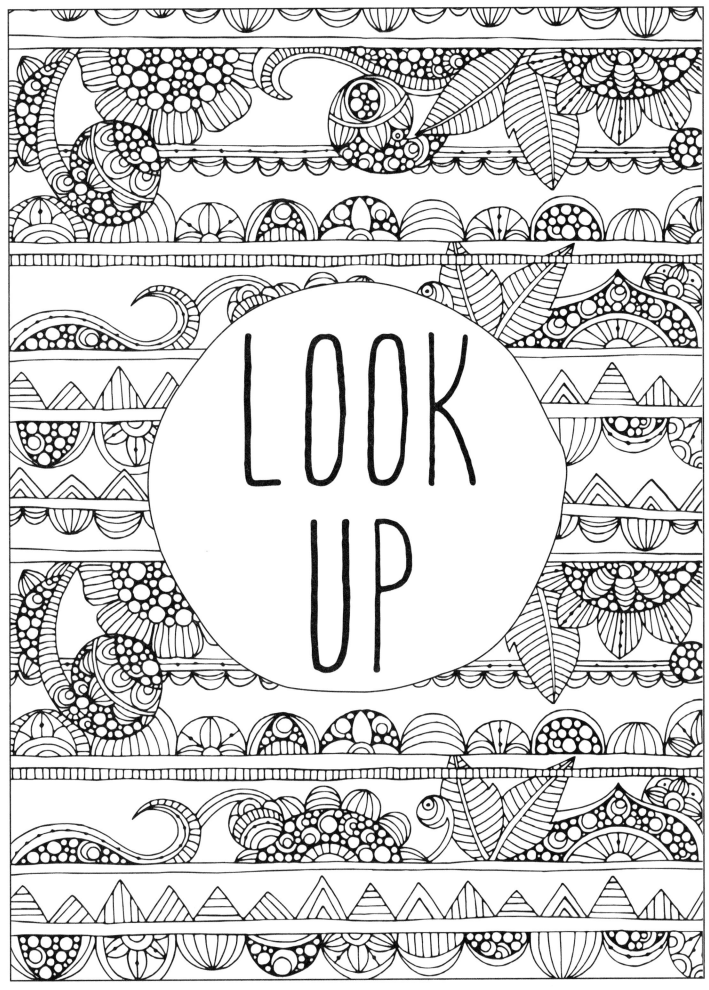

LOOK UP

No pessimist ever discovered the secrets of the stars,
or sailed to an uncharted land,
or opened a new heaven to the horizon of the spirit.

—Helen Keller

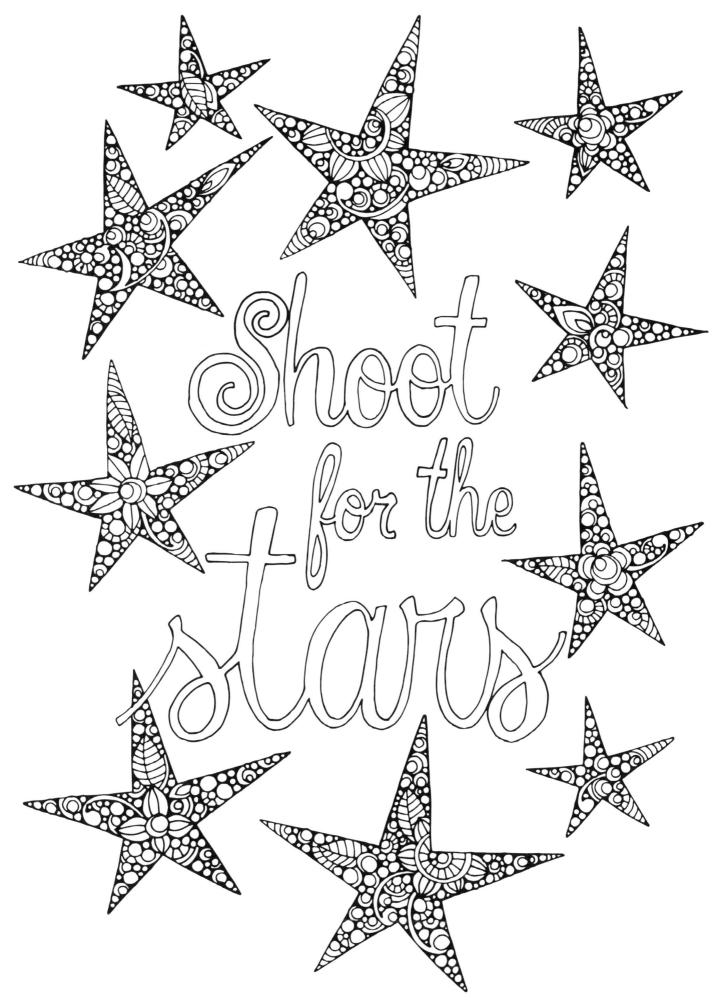

Only in the darkness can you see the stars.

—Martin Luther King, Jr.

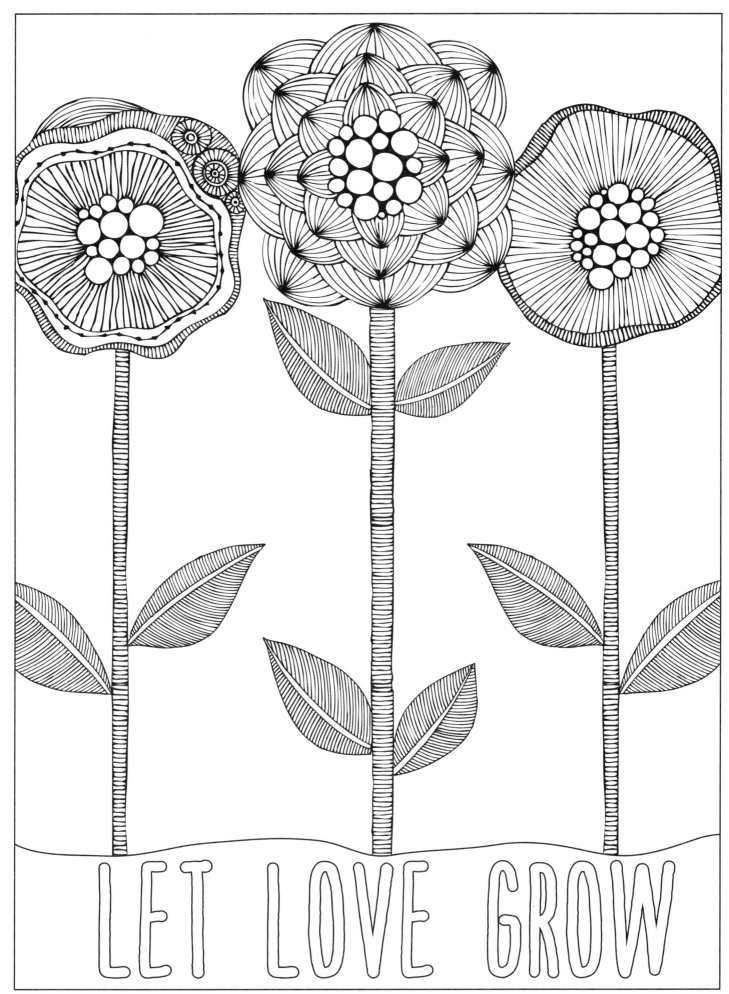

LET LOVE GROW

Love is old, love is new, love is all, love is you.

—The Beatles

Take pride in how far you have come
and have faith in how far you can go.

—Unknown

TODAY IS GOING TO BE AWESOME

Today's a wonderful day for you to create
a good "yesterday" for tomorrow.

—Unknown

Hope appears on the horizon each morning
in the form of a brand new day.

—Unknown

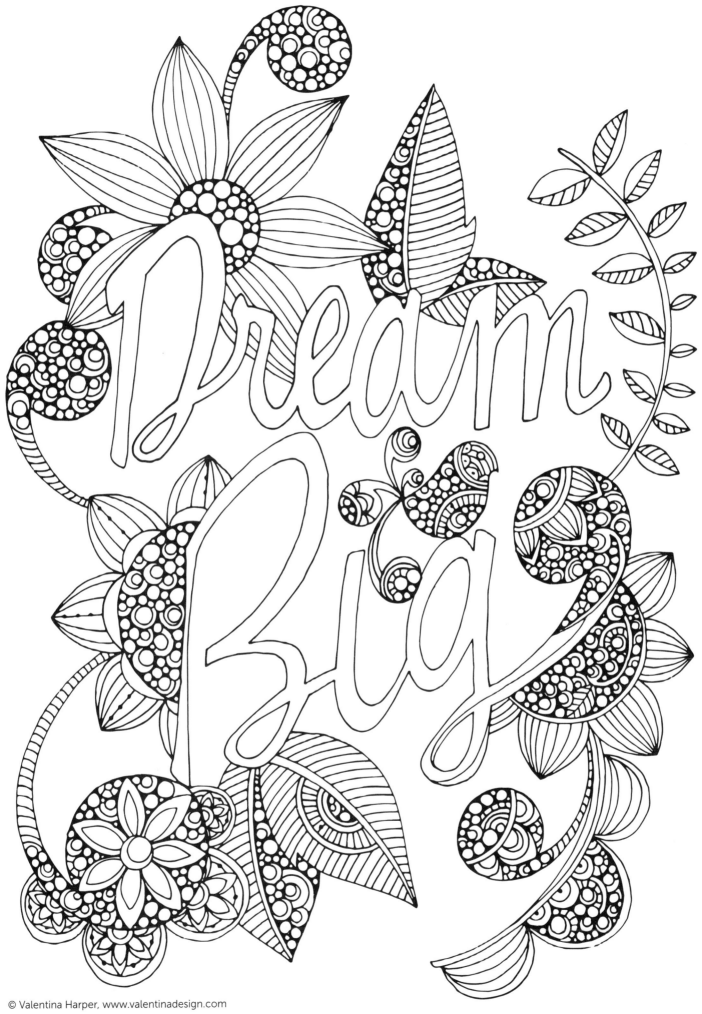

Sometimes your only available transportation
is a leap of faith.

—Margaret Shepard

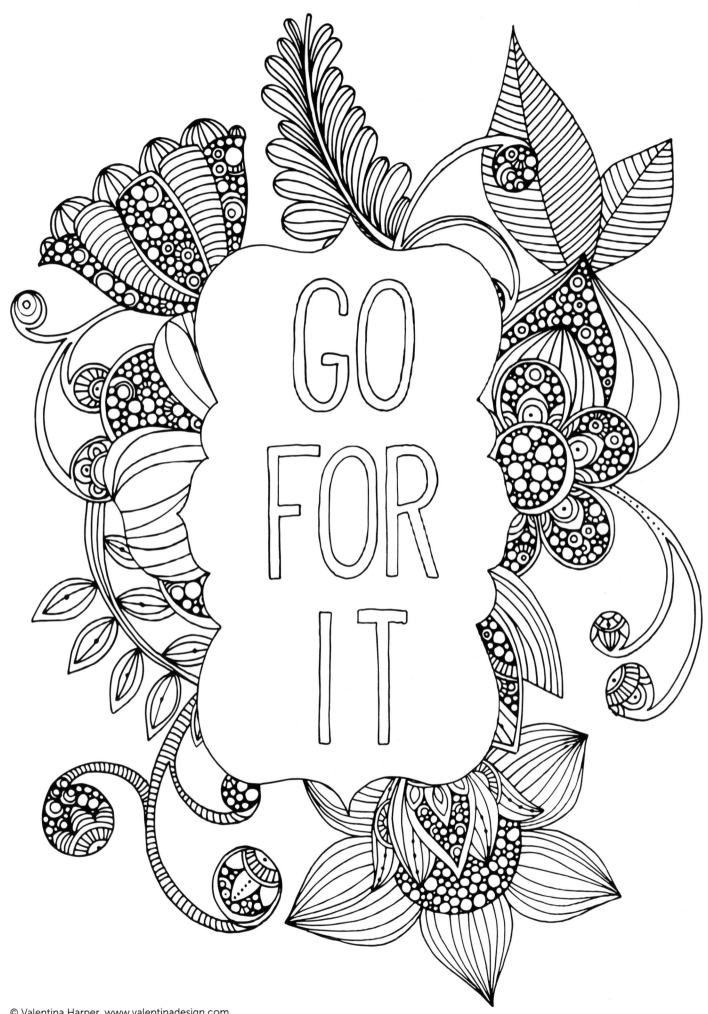

GO
FOR
IT

Opportunities are like sunrises.
If you wait too long, you miss them.

—Unknown

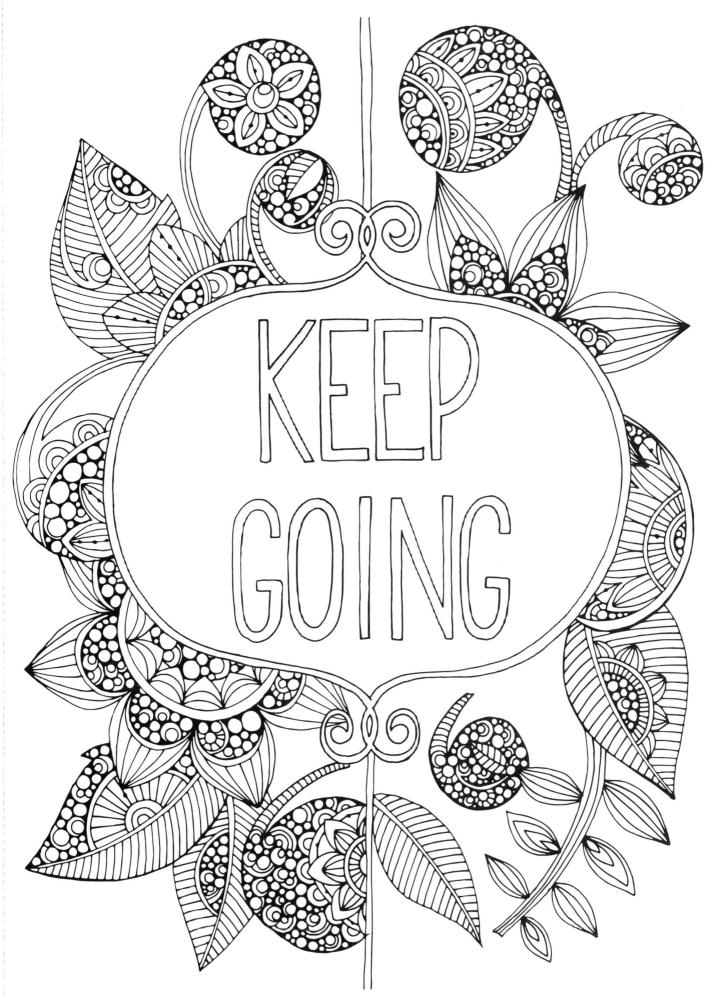

Sometimes when things are falling apart
they may actually be falling into place.

—Unknown